THE ART OF THE

IMPRESSIONISTS

Janice Anderson

A Compilation of Works from the
BRIDGEMAN ART LIBRARY

SHOOTING STAR PRESS

Shooting Star Press Inc
230 Fifth Avenue, New York, New York 10001

Impressionists

© Parragon Book Service Ltd 1994

This edition printed for:
Shooting Star Press, Inc.
230 Fifth Avenue - Suite 1212
New York, NY 10001

ISBN 1 56924 175 9

Printed in Italy

Editor: Alexa Stace
Designer: Robert Mathias

The publishers would like to thank Joanna Hartley
at the Bridgeman Art Library for her invaluable help

The Impressionists

IMPRESSIONISM WAS THE MOST important artistic movement in Western art in the 19th century and the first of the modern movements. After it came not just the obvious Neo-Impressionism and Post-Impressionism of the late 19th century, but also Fauvism and Cubism, developed by highly influential artists such as Cézanne, who had, at least in their early years as artists, practised the tenets of Impressionism.

At its beginnings in the 1860s in Paris, Impressionism seemed not to be a coherent movement in art but just one more group of painters trying to make their voice heard in the artistic whirlpool that was Paris in the second half of the 19th century. Impressionism did not rise spontaneously out of thin air; its theories and practice were linked back to earlier traditions in European art. It grew out of the experience of the generation of painters at work immediately before the young artists, including Monet, Pissarro, Renoir, Bazille, Sisley and Morisot, who were to become the major practitioners of Impressionism.

Post-Napoleonic France had seen great changes in its society, with new ideas about nature and science to the fore. Men like Delacroix showed that artists could legitimately make ordinary people and things the subject of their paintings, and that they could open their minds to the freedom of painting what they actually saw, and not what artistic convention dictated they ought to be seeing.

At the same time, landscape and open-air painting had been given new force through the work of artists like Constable in England and Corot and the members of the Barbizon group – so-called because of their practice of painting in the open air in the forest of Fontainebleau near Barbizon – in France.

The basic tenets of Impressionism were summed up, long before the name was thought of, by Eugène Boudin when he told the youthful Claude Monet: 'Everything painted directly and on the spot has a strength, vigour and vivacity of touch that can never be attained in the studio; three brushstrokes from nature are worth more than two days' studio work at the easel.' What the Impressionists were trying to do with paint was to reproduce as truthfully as possible the intensely rich visual experience which the human eye conveyed to the mind. They sought to analyse the colour and tone of a given subject as exactly as possible and to paint the play of light on the surfaces of objects.

Impressionism got its name by chance. A group of young artists – Monet, Pissarro, Renoir, Sisley, Cézanne, Boudin, Morisot and others – had been working together for some years. Often their most cherished paintings were rejected by the official Salon, so they decided to mount an exhibition solely of their work in Paris in 1874. They called themselves *Société anonyme des artistes, peintures, sculpteurs, graveurs etc.* Among the works submitted by Claude Monet was one of the sun rising over the harbour at Le Havre. Rather on the spur of the moment, he called it *Impression: Sunrise*. The title was seized on by an art critic, Louis Leroy, who headed his far from admiring review of the exhibition in the magazine *Charivari* 'Exhibition of the Impressionists'.

In their emphasis on the importance of painting from nature, of painting quickly to achieve a direct expression of the light and colour in the subject in front of them, the

artists of the *Société anonyme* had neglected elements hitherto considered essential in great painting. Fine composition, serious content and a perfect finish – all seemed lacking in the paintings Leroy saw at that first exhibition at No. 35 boulevard des Capucines in Paris. Even their daring and innovative use of colour failed to please him.

Despite the more-or-less hostile reaction of the general public to the exhibitions mounted regularly in the 1870s and 80s by the Impressionists – a name they accepted reluctantly since they did not see themselves, in any sense, as a coherent group – these were their finest years, with the Impressionist artists producing hundreds of masterpieces which are still major attractions in the world's leading art galleries.

By the time the eighth and last exhibition of independent artists (the word 'Impressionist' was never attached to these exhibitions) was held in 1886, many artists working within the Impressionist movement were questioning where it was taking art. Degas, Renoir, Seurat, Gauguin and Cézanne were all rejecting pure Impressionism – to which, it must be said, they had not been entirely devoted as artists, anyway – and seeking new ways of expressing their artistic ideas and theories of colour and shape in paint.

While Seurat came up with Divisionism and Cézanne's work lead to Cubism, many of the Impressionists, including Monet, Pissarro and Sisley continued producing more or less purely Impressionist paintings of great vigour and beauty for many years. Their influence was felt way beyond the bounds of 19th-century France. The way in which they directly expressed their visual experience and the boldness with which they handled light and used colour remained a challenge to all other artists for several generations to come.

▷ **The Beach at Trouville**
1864
Eugène Boudin (1824-98)

Oil on canvas

EUGENE BOUDIN was an unassuming man, the son of a bookseller in Le Havre who himself started out as a shopkeeper, specializing in art materials and prints. A self-taught amateur painter, Boudin was persuaded by Millet's approval of his work to devote himself wholly to art. By the time he had spent two years copying the works of artists in the Louvre, he had persuaded himself that the studio was not an acceptable alternative to painting on the spot, in the open air. This belief, followed all his life, was Boudin's great contribution to Impressionism, for it was his example that persuaded Claude Monet and others of his generation to leave their studios behind and paint in the open air. Although Boudin exhibited at the first Impressionist Exhibition in Paris in 1874, he was too independent to join the group, and spent most of his life in his beloved Normandy, painting the seas and skies of the coast.

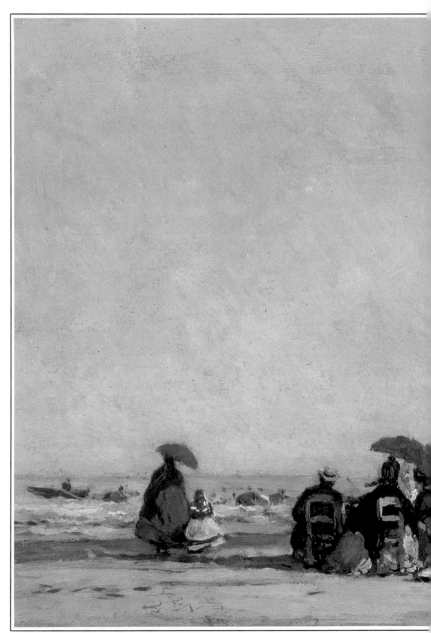

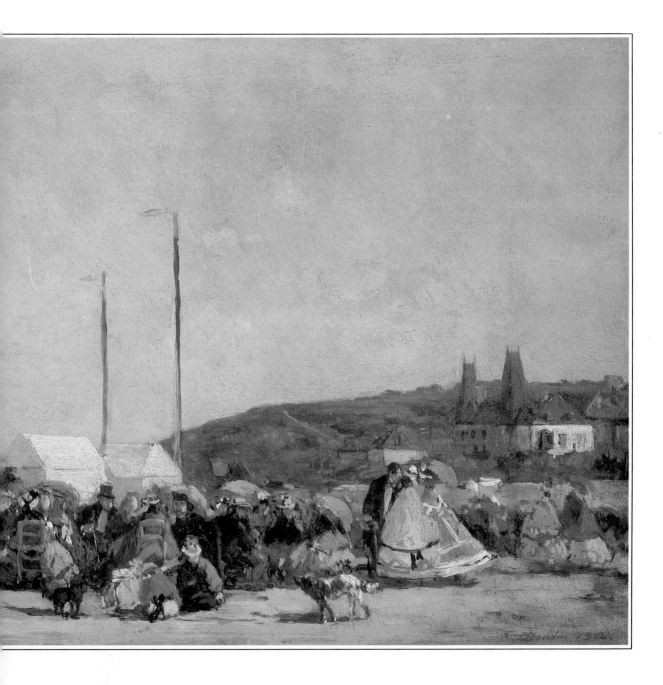

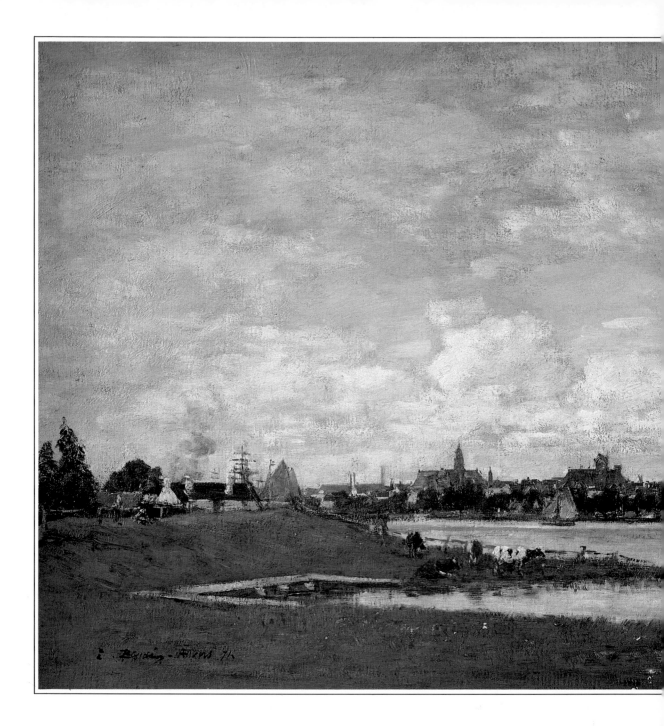

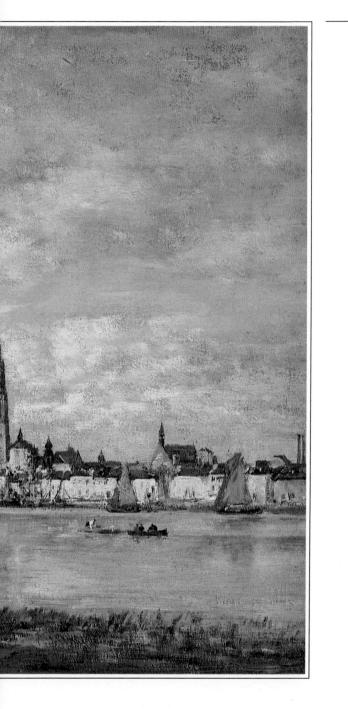

◁ **Anvers from the Tip of Flanders** c 1871
Eugène Boudin

Oil on canvas

EUGENE BOUDIN has been called a father of Impressionism, and this superb view of the Belgian town of Anvers (Antwerp) shows why. Boudin's ever-present concern to depict the effect of light on a scene and to set on canvas its true atmosphere has resulted in a painting that is full of a wonderful airiness and freshness. The scene, which recalls the work of Dutch artists like Vermeer, is unusual for Boudin, most of whose work was done in Normandy. However, it includes several characteristic features of his French beach scenes, particularly the wide, spacious sky and the low horizon. It was paintings such as this which inspired the young Monet to remark, 'My eyes were really opened, and I finally understood nature. I learned at the same time to love it.'

▷ **The Road to Sydenham** 1871 Camille Pissarro (1830-1903)

Oil on canvas

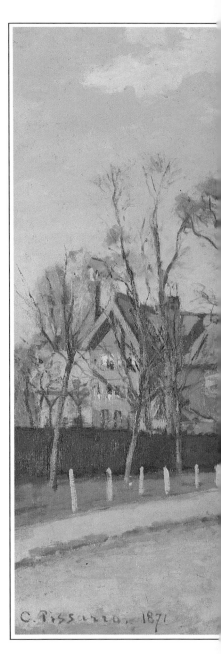

CAMILLE PISSARRO was born on St Thomas, in the Danish Virgin Islands, where his French-Jewish father was a businessman. He was sent to school in Paris and for a time worked in the family business on St Thomas. From early on in life, painting was his great interest, however, and by 1855 he had abandoned all thought of a business career in favour of art. In 1859, the year in which he met Claude Monet, he exhibited for the first time at the Paris Salon. The painting was a landscape, a genre which was to interest him throughout his life. Pissarro was one of several French artists who crossed the Channel to England to escape the Franco-Prussian War of 1870 and the siege of Paris which followed it. Pissarro and his family spent some time in south London, near the Crystal Palace, where he painted several local scenes, including this one of the road to Sydenham, and exhibited his work at the Bond Street gallery of the French dealer, Durand-Ruel. Returning to France in 1871, Pissarro found that the Prussian soldiers who had occupied his house in Louveciennes had virtually destroyed 20 years' work, and had even used his paintings as duckboards.

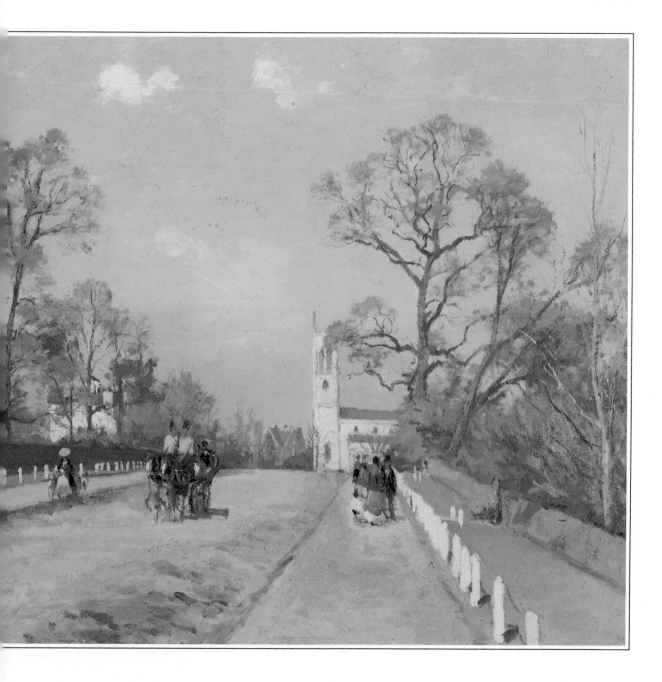

▷ **The Great Bridge at Rouen** 1896 Camille Pissarro

Oil on canvas

PISSARO FIRST MADE sketches for paintings at Rouen in 1883, but it was after seeing an exhibition of Monet's great series of paintings of Rouen Cathedral in 1895 that he really got down to an idea that had been in his mind for several years: painting a series of works of one place at different times and in different weather conditions. Like other Impressionists, Pissaro was greatly struck by the unity of style and content which could be achieved in a series. Rouen's Pont Boïeldieu, often called Le Grand Pont, had been built in 1885 and was a striking feature of the river area of the city. It was present in many of the 47 views of Rouen Pissaro was to paint in three series in 1896 and 1898 and was painted in various weather conditions – in mist, in rain, with the Seine in flood, at sunset, in fog and in bright sunlight. The vantage point for many of the pictures was a window in a set of rooms Pissarro had hired in a hotel overlooking the river and Rouen's busy harbour.

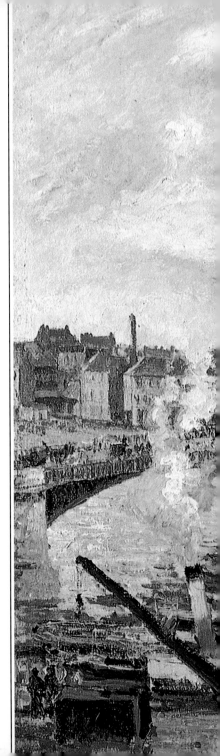

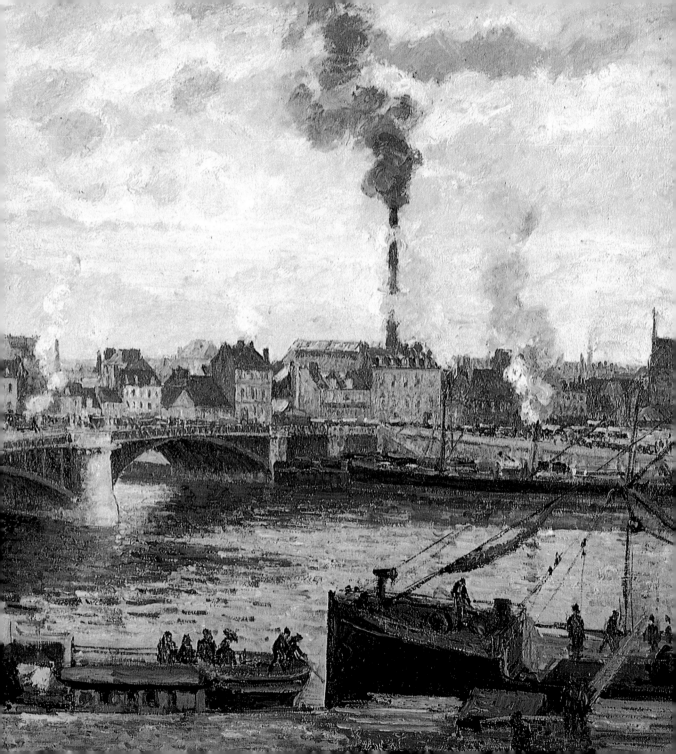

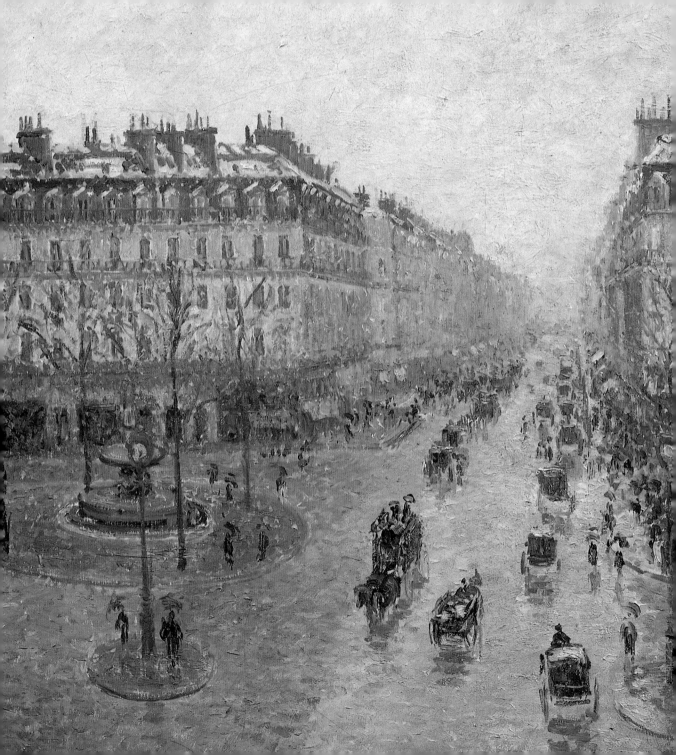

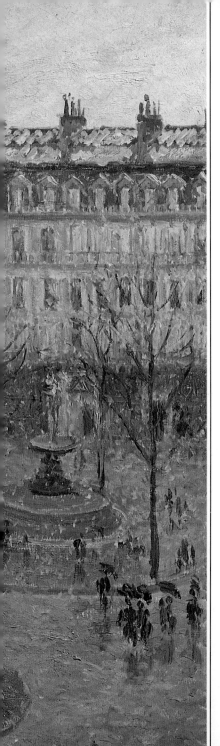

◁ **Avenue de l'Opéra: Snow Effect** 1899 Camille Pissarro

Oil on canvas

AMONG PISSARRO'S several Paris series of the 1890s was one of the Avenue de l'Opéra: 15 paintings focusing on the Avenue de l'Opéra itself, on the rue Saint-Honoré and on the Place du Théâtre Français. Among the views of the Avenue de l'Opéra, looking down the street to the Palais Garnier, were two subtitled *Snow Effect.* Both depicted the effect of a fall of snow on the street and the buildings, trees, carriages and people in it, and on the light and atmosphere. This picture might have been subtitled 'less snow effect' for, in contrast with the other 'snow effect' picture which was obviously painted shortly after a snow-fall, the snow has all but disappeared at ground level, reduced to a creamy slush on the roads and a grey slush on the pavements, with just a suggestion of heaviness in the branches of the trees. Only on the roofs of the buildings is the snow lying in any depth. The atmosphere, brilliantly caught by Pissarro, is that special lightness, reflected from sky to street,which remains when snow clouds have dispersed.

▷ **Pilots' Jetty, Le Havre: Morning, Grey Weather** 1903
Camille Pissarro

Oil on canvas

LE HAVRE was the subject of Pissarro's final series, done in the last year of his life. We are told that Pissarro chose Le Havre rather than Dieppe, where he had worked before, because the hotels and the food they served were better in Le Havre: Pissarro had reached that time of life when personal comfort was an important consideration. Besides, his 'collectors', as Pissarro called the people who bought his paintings, would like Le Havre, with 'the coming and going of the boats and the beautiful and great skies of France'. Both aspects of Le Havre are very much in evidence in this wonderfully atmospheric picture. In practical terms, Pissarro was recording for posterity a pilot's jetty and harbour which were soon to be demolished to make way for something bigger; in artistic terms, his only concern was to depict the atmosphere at a particular time and in particular weather.

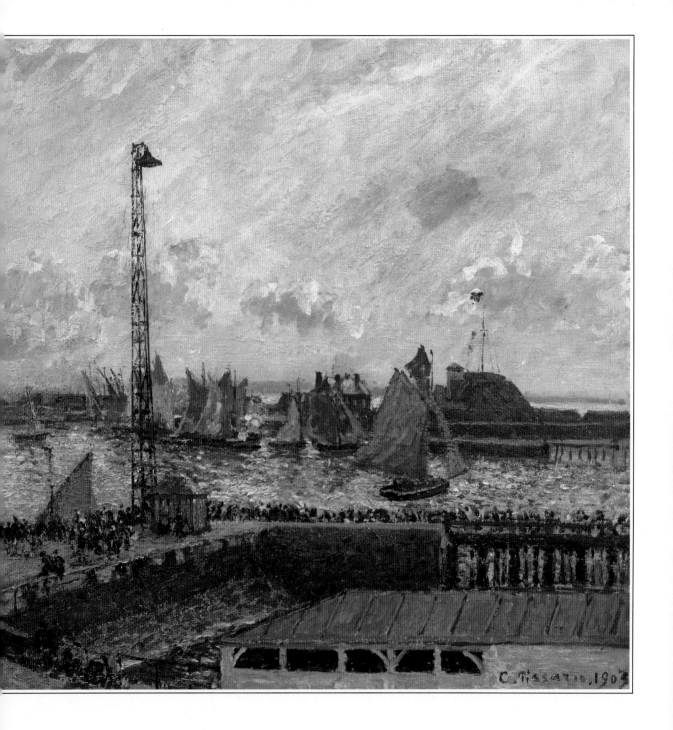
C. Pissarro. 1903

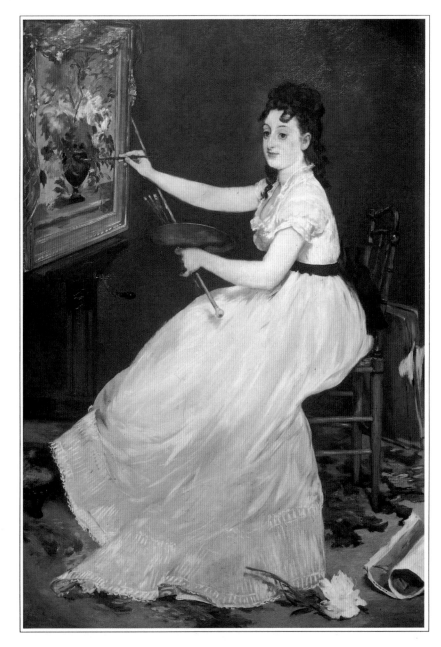

◁ **Eva Gonzalès** 1870
Edouard Manet (1832-83)

Oil on canvas

ALTHOUGH HE HAS COME to be considered one of the leaders of Impressionism, Manet never regarded himself as such. And although his painting came to exhibit many of the characteristics of Impressionism, he was well into his 40s before he adopted its techniques and he never exhibited with the Impressionist painters. Despite his well-off, middle-class background, Manet was always a revolutionary in the world of art in France, with the hostile receptions given such paintings as *Le Déjeuner sur l'Herbe* and *Olympia* in the 1860s now part of art history. This portrait of his only pupil, Eva Gonzalès, while done in Manet's 'Old Master' style, indicates something of a transition in his art. It combines the unemotional realism of his 'avant-garde' work of the 1860s with the lighter palette and concentration on the effects of light which were the results of his increasingly close relationship with the younger artists of the time, particularly Monet.

▷ **Argenteuil** 1874
Edouard Manet

Oil on canvas

ARGENTEUIL, a village on the Seine just 15 minutes by train from the Gare Saint-Lazare in Paris, has a place of honour in the history of Impressionism because so many painters stayed there and depicted the relaxed and carefree life of its boating centre and places of entertainment. Manet's delightful picture of a couple in holiday mood on a boat was painted at a time when he was working at Argenteuil with Monet and Renoir. It is a truly Impressionist picture, painted completely *en plein air,* and with an intricate mixture of light colours, dotted with the black which was so typical of Manet's work, to give a beautiful luminosity to the scene.

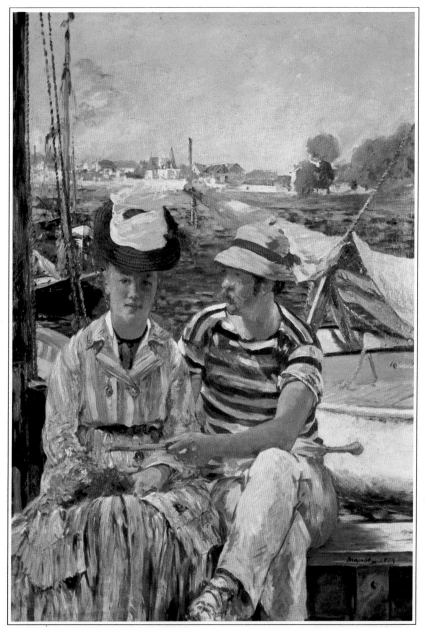

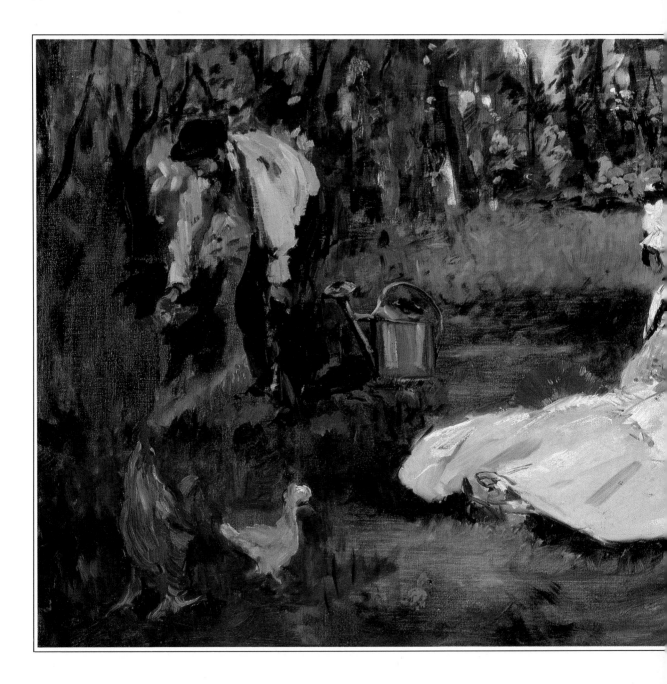

◁ **The Monet Family in the Garden** 1874
Edouard Manet

Oil on canvas

1874 WAS A momentous year for the Impressionists, with their first exhibition, which resulted in their being dubbed 'Impressionists', being held in Paris in the spring. Summer found several of them, including Monet, Renoir and Sisley living in or near Argenteuil. Manet was also nearby, having been persuaded, partly by the influence of his sister-in-law, Berthe Morisot, to work in the open air. Both Manet and Renoir painted pictures of the Monet family in the garden of their house in Argenteuil. Manet's interest in the subject was perhaps made all the keener by the fact that he had actually found the house for Monet when the latter was evicted from another house in the village because he could not pay the rent. No sign of financial stress mars this idyllic scene. Sunlight filters through the trees to fall upon the figures of Camille Monet and their eldest son Jean, while Claude Monet tends his garden in the background.

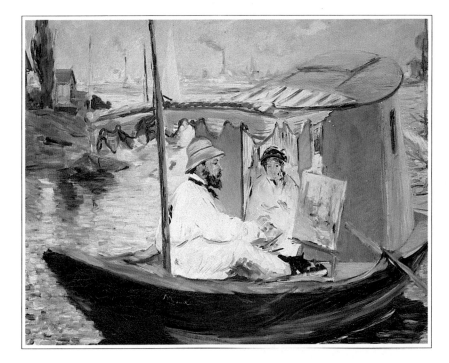

△ **Monet Working in His Studio Boat** 1874 Edouard Manet

Oil on canvas

THROUGHOUT the wonderfully productive summer of 1874 at Argenteuil, when several Impressionists were working together, Monet kept a boat which he used as a floating studio, taking his passion for painting in the open air out on to the broad waters of the Seine. Manet, fully aware of the importance of *plein-airisme,* as open-air painting came to be called in Impressionist theory, chose to record for posterity Monet and his boat. In so doing, he also left us a delightful insight into the life of the Impressionists at this time.

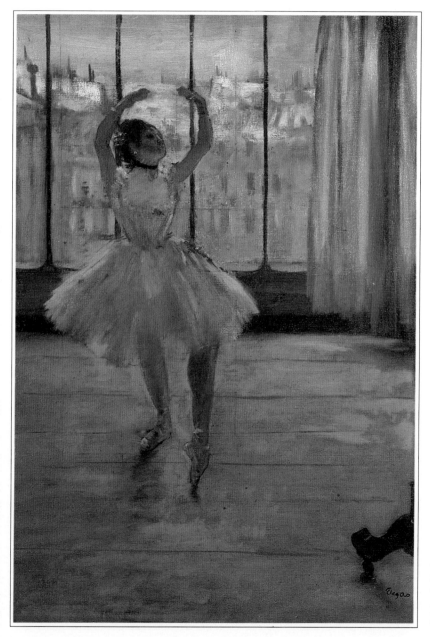

◁ **Dancer in Front of the Window** c 1874
Edgar Degas (1834-1917)

Oil on canvas

DANCING, a pastime very much in the spirit of the times in post-Empire France, was a popular subject with the Impressionists. Renoir's work, in particular, included several superb paintings of people enjoying dancing. Degas's interest was rather different: while wanting to paint the contemporary scene, he chose to depict the hard work behind the public grace of a professional dancer's life, studying the dancers' movements and trying to convey them on paper or canvas in the same way as he had studied the movements of horses and jockeys at the racecourse. This finely observed study of a dancer apparently practising her movements in front of a mirror is typical of the many paintings and drawings Degas was to do at the Paris Opéra, beginning early in the 1870s. Later in life, when failing eyesight made drawing difficult, Degas turned to sculpture, often modelling the dancers in wax to be cast in bronze.

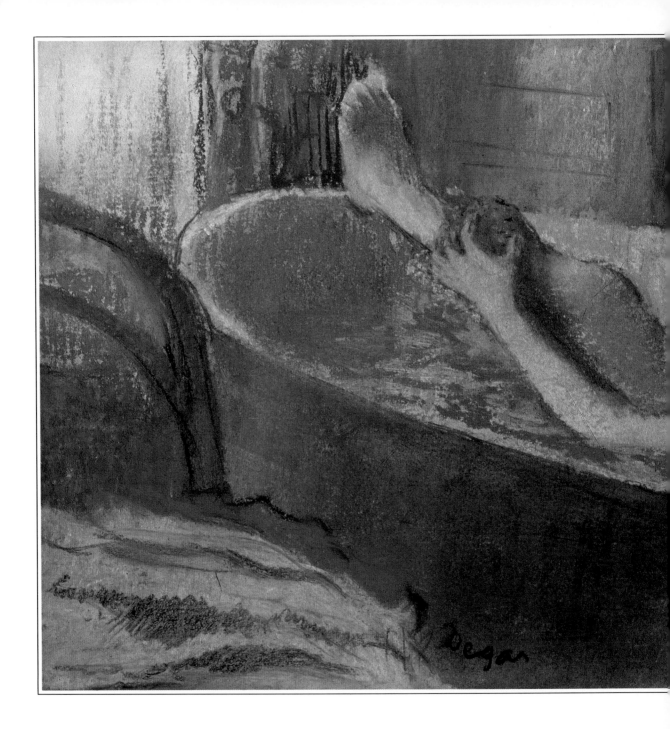

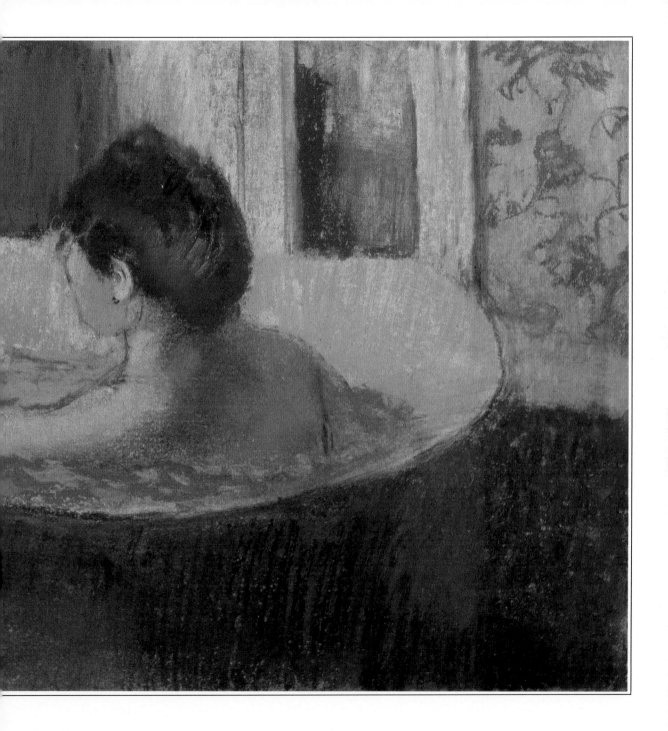

Woman in Her Bath,
Sponging Her Leg 1883
Edgar Degas

Pastel

◁ *Previous pages 26-27*

IN HIS YOUTH, Degas had been
an admirer of Ingres and of
classical painting, with its
mythological scenes of
goddesses bathing. In this
picture, he eschews mythology
for reality. Here is no heavenly
stream, but a tin bath; no
goddess, but an ordinary
woman unself-consciously
washing herself. What he was
aiming at, Degas confessed, was
the effect of peeping through
the keyhole, of depicting people
as they really were, going about
everyday matters as if quite
unobserved. Degas included
several pastels like this in the
last Impressionist Exhibition in
1886, where their realism was
still unconventional enough to
cause something of a stir.
George Moore wrote of Degas's
pictures in this exhibition that
he drew 'not by the masses but
by character; his subjects are
shopgirls . . . but the qualities
that endow them with
immortality are precisely those
which eternalize the virgins and
saints of Leonardo da Vinci . . .'

▷ **Woman Combing Her Hair** c 1887-90 Edgar Degas

Pastel

DEGAS WAS THE SON of a well-
off banking family; portraits of
him suggest a sophisticated,
urbane man-about-town, who
might well have become an
academic painter in the
conventional style. It was a
meeting with Manet in 1862,
and friendship with younger
painters at the forefront of the
new ideas in painting,
including Monet, Renoir,
Pissarro and Berthe Morisot,
that drew him towards
painting in the current modes
of realism and impressionism.
Never interested in working
out-of-doors, Degas allied the
Impressionists' search for
naturalism and atmosphere,
using pure colour, to his
superb skills as a draughtsman
to produce some of the
greatest masterpieces of
Impressionism – indoors. He
found that using pastel gave
him a greater freedom to
draw and apply colour at the
same time than was possible
with oil. This drawing of a
woman going about an
everyday task shows Degas
combining colour and form
with ease.

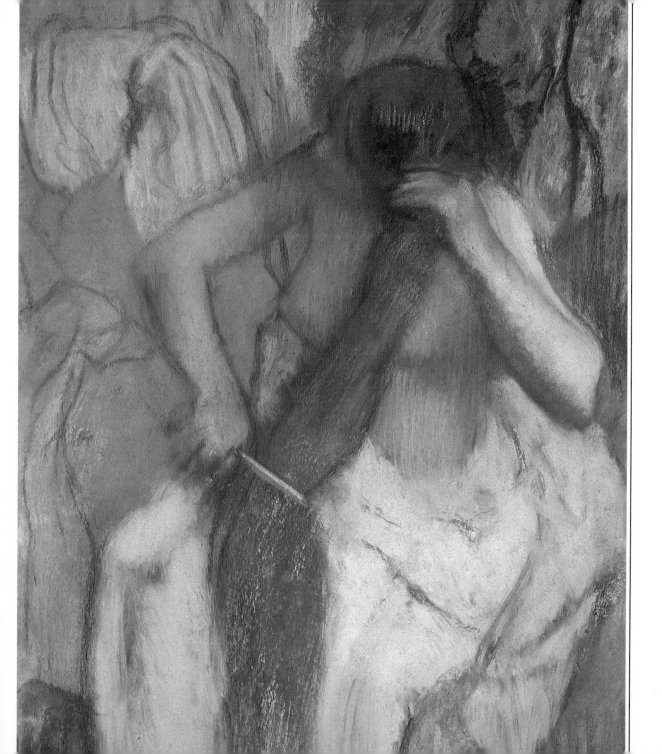

▷ **The Artist's Studio** c 1867-8
James McNeill Whistler
(1834-1903)

Oil

AMERICAN-BORN Whistler is
usually considered as an artist
who 'hovered on the brink of
Impressionism' rather than
one who plunged
wholeheartedly into the
movement. A colourful figure,
especially in the artistic life of
London, where he lived much
of his adult life, Whistler's first
artistic experiences in Europe
were at Gleyre's studio in
Paris, where Monet, Renoir
and Sisley were all to study
later. Whistler was one of the
first artists of his generation to
take a keen interest in
Japanese art and signs of his
influence are apparent in the
works of the Impressionists,
including Degas and Monet,
who was impressed by
Whistler's atmospheric
Nocturnes of the 1870s.
This oil sketch of Whistler's
London studio, intended as a
preliminary study for a much
larger painting which he
never executed, shows
Whistler working in the
Japanese manner.

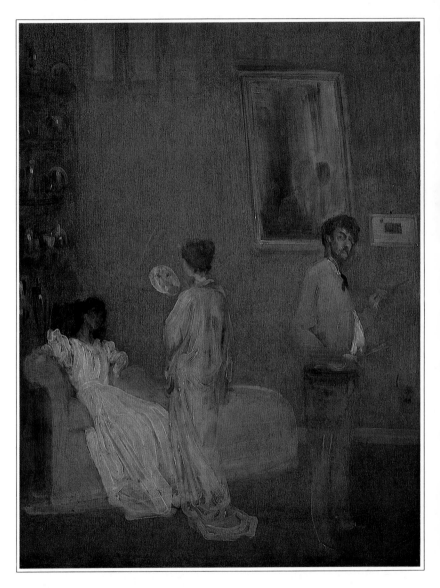

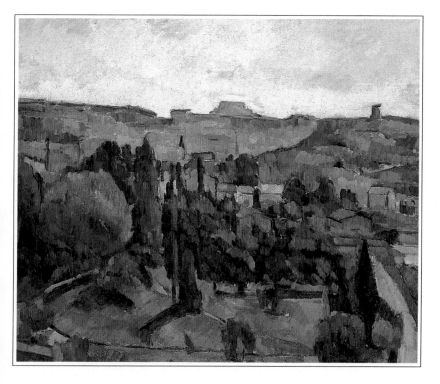

△ **Paysage d'Ile de France** c 1879 Paul Cézanne (1839-1906)

Oil on canvas

PAUL CÉZANNE was born in Aix-en-Provence and spent most of his maturity working in the south of France. A considerable part of his early adulthood was spent in the north, however, as he had begun his art studies in Paris in 1861 and spent some time working in the countryside round Paris. Among his earliest friends in the art world of Paris was Camille Pissarro, who was to be of great support to him, both in the business of getting his work shown and in the quality of the advice he gave the younger man. Pissarro was influential in turning Cezanne's thoughts towards landscape painting and the study of nature. This landscape, probably painted some years after Cézanne and Pissarro had worked together at Pontoise and Auvers in the early 1870s, already shows Cézanne's mature style. The paint is applied in small, flat strokes, each one describing the plane of the object he is painting and, at the same time, carefully relating to the other forms of the painting.

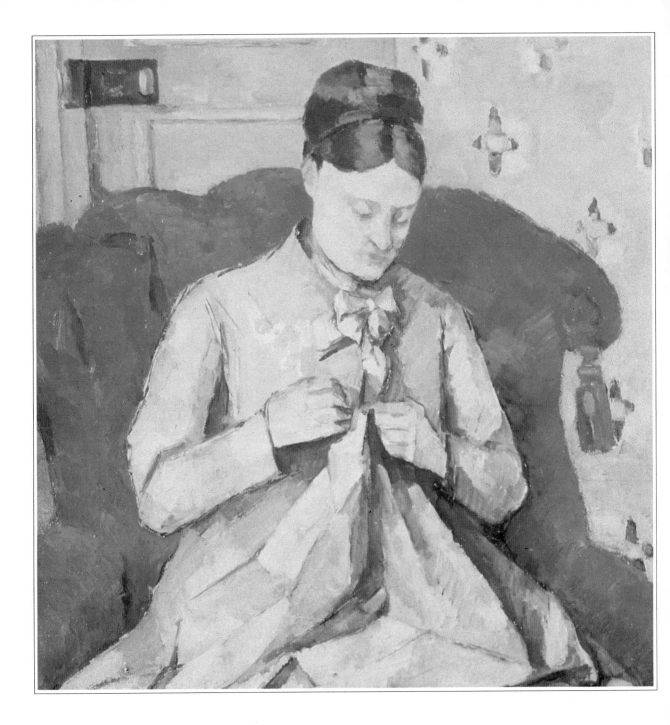

◁ **Madame Cézanne Sewing**
Paul Cézanne

Oil on canvas

HORTENSE FIQUET, originally
Cézanne's model and mistress,
became his wife after she had
given birth to their son, and
she remained a favourite
model throughout their
marriage. There are some 18
portraits of her in existence, of
which this is one of the more
'domestic', since it shows her
not just sitting quietly in a
chair, but engaged in a
household chore. Sittings for
Cézanne tended to be long
and tedious, since he was a
slow and deliberate painter,
agonizing for long periods
over every brushstroke. What
mattered to him was not the
character of the sitter so much
as his or her structure, with
the relationship of shapes and
planes being as important in a
picture of a person as they
were in still lifes. In his
paintings of people Cézanne
achieved a degree of
simplification which
prefigured the work of artists
such as Modigliani in the 20th
century.

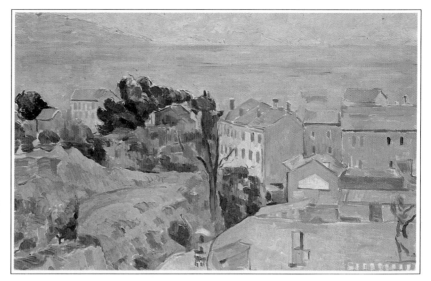

△ **View of L'Estaque** Paul Cézanne

Oil

L'ESTAQUE IS SET on a ridge of
hills to the west of Marseilles.
Cézanne first went there
during the Franco-Prussian
war of 1870, and it was to
figure in many of his paintings
over two decades. In his
studies of the mountains, sky
and sea of the area, he was
always searching for a
successful resolution of the
problem of how to integrate
solid objects with large empty
spaces in a way which would
produce a satisfying painting.
He spent many hours studying
the structure of the rocks and
trees as revealed by the strong
morning or evening sunlight.
His work acquired a great
formal strength, which so
impressed Auguste Renoir
when he visited his old friend
at L'Estaque that he resolved
to adopt a tighter, more formal
line in his own work.

▷ **The Station at Sèvres** c 1879 Alfred Sisley (1839-99)

Oil on canvas

BORN IN PARIS of English parentage, Alfred Sisley was one of the founding group of Impressionists. He had met Monet, Renoir and Bazille at Gleyre's studio in the 1860s and had discovered early on how well painting *en plein air* suited his artistic temperament. After his father's business failed in 1871, partly as a result of the Franco-Prussian War, Sisley was always poor, struggling to keep his family going solely on the sale of his paintings. It was poverty which kept the Sisley family on the move, shifting from one cheaply rented house to another in villages on the Seine outside Paris. Sèvres was one such and there are several views of the town and its railway station among Sisley's work. This one is a particularly attractive example of Sisley's style. The division of the painting into three hoizontal bands, broken by the vertical lines of the trees, is typical of his style, as is the broad expanse of the sky covering half the canvas. The summer sun is also wonderfully presented, drenching the scene with its heat.

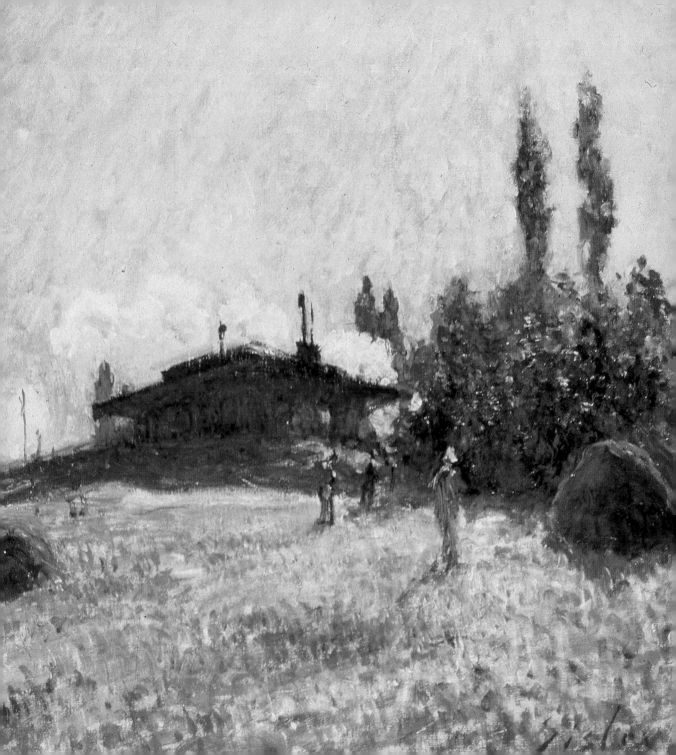

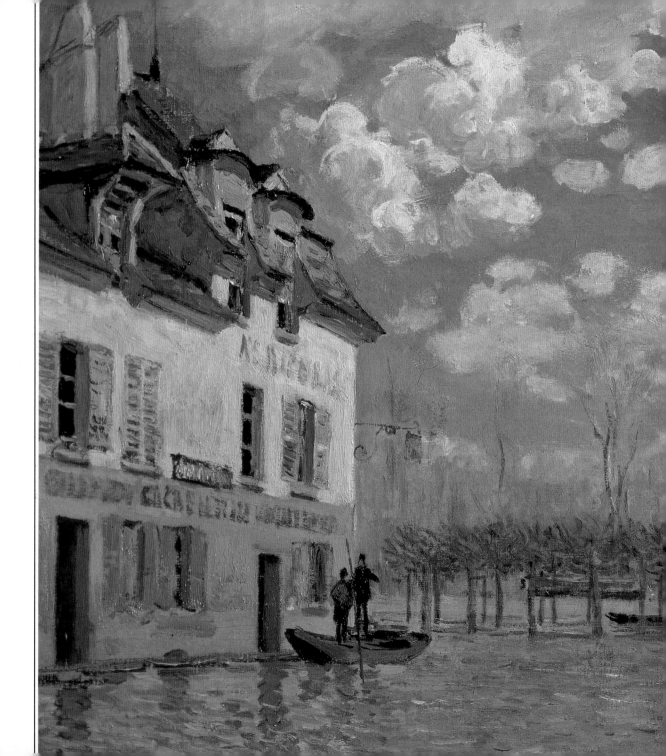

◁ **The Boat During the Flood at Port-Marly** 1876
Alfred Sisley

Oil on canvas

SISLEY'S SIX PAINTINGS of the floods which swamped the Seine village of Port-Marly, west of Paris, in the spring of 1876 are among the finest of his works, painted with a wonderful delicacy of colour and a sensitive awareness of the effect of the light on buildings, trees and water. Of all the Impressionists, Sisley was one of the finest painters of water, particularly rivers.

In this picture, Sisley is recording Port-Marly with the floods receding. The grey, rain-laden skies which dominated other pictures in the series have given way to a spring-like blue, with white clouds very much in evidence: they are even reflected in the white-flecked river. The broken brushwork gives movement and texture to the picture.

▷ **Landscape at Moret-sur-Loing** 1880s Alfred Sisley

Oil on canvas

THE MEDIEVAL TOWN of Moret-sur-Loing, with its fine old church and picturesque bridge, began to feature in Sisley's work from the mid 1880s. A house in the town was his home in the last decade of his life, when he painted Moret and the surrounding countryside to the exclusion of almost anything else. In this view of the town in high summer, Sisley concentrates on the canal which had been cut from the river Loing north of the town as a waterway for barges. It was a subject Sisley returned to again and again, in all weathers and at all times of the year. Always as interested in the working aspects of a place as in its more relaxed aspects, Sisley has included in the foreground of his picture some of the canal's lock-side machinery.

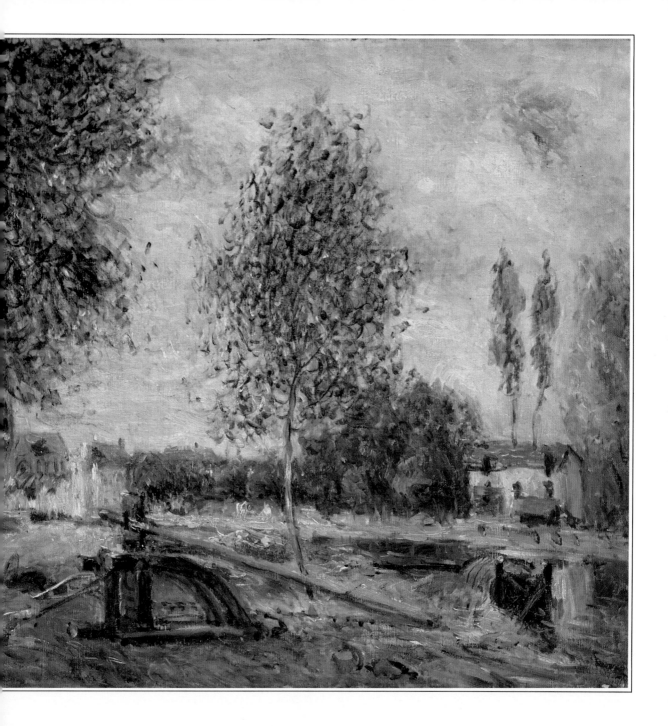

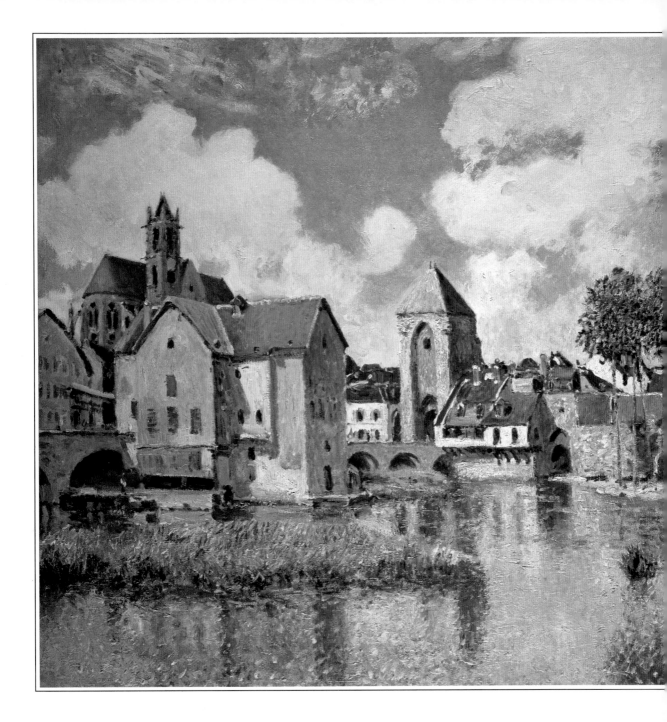

◁ **Moret-sur-Loing** 1891 Alfred Sisley

Oil on canvas

WRITING TO A FRIEND in the 1880s, Alfred Sisley noted that the effects of light had an almost material expression in nature, and must be rendered in material fashion on the canvas. 'Objects must be portrayed in their particular context, and they must, especially, be bathed in light, as is the case in nature', he wrote. This painting of Moret-sur-Loing perfectly illustrates what he meant. A bright summer sun lies across the painting, bathing parts of the scene in a clear light and leaving others in shadow. The effect is to give the picture an almost three-dimensional quality. Sisley was to return to this group of buildings again and again, painting them from many different viewpoints. The church itself was the subject of a series Sisley did in the 1890s, at a time when Monet was painting his Rouen Cathedral series and Pissarro his Rouen bridge and Paris streets series.

▷ **The Picnic (Déjeuner sur l'Herbe)** 1866
Claude Monet (1840-1926)

Oil on canvas

OF ALL THE IMPRESSIONISTS, Sisley and Claude Monet were the ones who remained most faithful to the principles of the movement. Born in Paris, Monet discovered early the excitement of fresh air and open skies, for his family moved to Le Havre when he was a child. It was there he met the painter Boudin, who inspired him with an enthusiasm for open-air painting. The mid-1860s found Monet established – or at least struggling – in the artistic world of Paris. He had already rejected the academic tenets of painting taught at Gleyre's academy and, like Renoir and Sisley, was concentrating on painting in the open air. This painting, an oil sketch for a much larger painting Monet planned to do for the 1866 Salon but never completed, was intended as a reworking of the theme of Manet's *Déjeuner sur l'Herbe* which had created a scandal when shown at the Salon des Refusés in 1863.

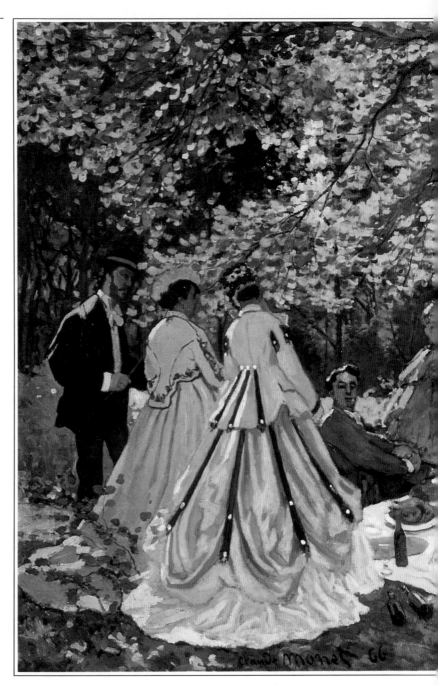

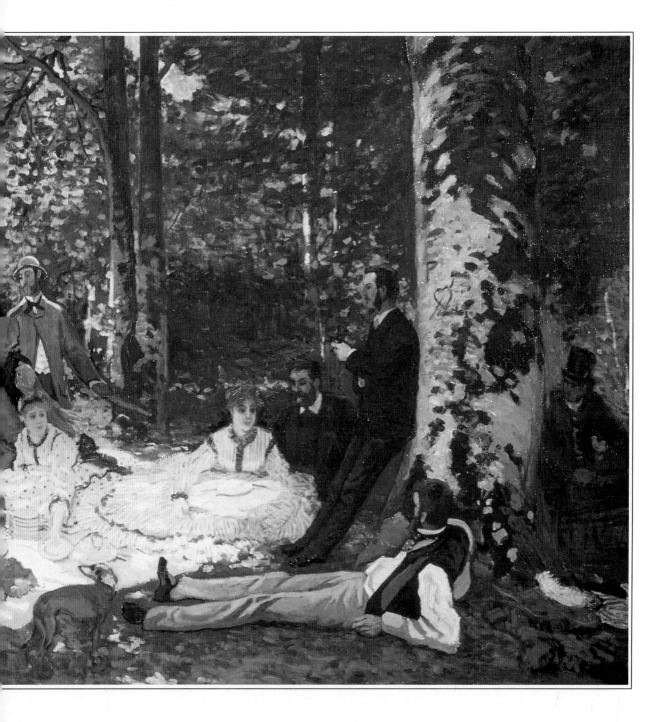

◁ **A Meadow in Giverny** 1888
Claude Monet

Oil on canvas

MONET BOUGHT a house in the village of Giverny in the valley of the Seine in 1883. Though he made many trips away from Giverny, especially in the 1880s, it remained his base and his home for the rest of his life. There he planned and planted a magnificent garden and in the countryside around Giverny he did many paintings, most of them simple subjects, such as this gentle meadow, all of them lifted out of the conventional by the delicately varied tones of the colours he used and the varied angles of his brushwork. It was in a meadow such as this that Monet began the series paintings which dominated the work of his last years. The subject of his first series was haystacks. Then came poplars, Rouen Cathedral and finally waterlilies.

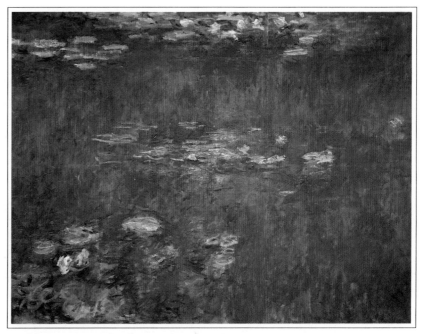

△ **Waterlilies: Green Reflections (central)** 1916-22
Claude Monet

Oil on canvas

MONET BEGAN CREATING a water garden at Giverny in the 1890s. He diverted a stream to make a pond, built a Japanese-style bridge over it and began growing waterlilies in the pond. Monet's paintings of his garden began to concentrate on the pond and the waterlilies, with whole paintings focusing on the changing light reflected on them. Monet's last and greatest series was a collection of huge canvases, intended for hanging as a group, showing his beloved lily pond and its flowers. Near the end of his life, he selected a number of the paintings for hanging in two oval rooms in the Orangerie in Paris, where they may be seen today. This painting is the central panel of one of them.

▷ **The Fisherman** 1873-4
Pierre Auguste Renoir
(1841-1919)

Oil on canvas

RENOIR BEGAN HIS artistic life
as an apprentice porcelain
decorator, which may have
contributed to the delicate
touch which later gave such a
special glow to his paintings.
He was one of the young
artists working in Gleyre's
studio in Paris in the early
1860s, where he was soon
exchanging ideas with Monet,
Sisley, Bazille and others. This
delightfully atmospheric
picture was painted near
Argenteuil, where Renoir
often visited Monet. At the
same time, Renoir was also
painting more conventionally
academic portraits to sell to
wealthy patrons, among which
*Madame Charpentier and Her
Children* (1878), would become
one of the best-known. It was
M Georges Charpentier who
bought *The Fisherman* for a
mere 180 francs at an auction
at the Hôtel Drouot in Paris
organized by Renoir, Monet,
Sisley and others in 1875 in
the hope that it would bring
them new buyers and some
desperately needed money.

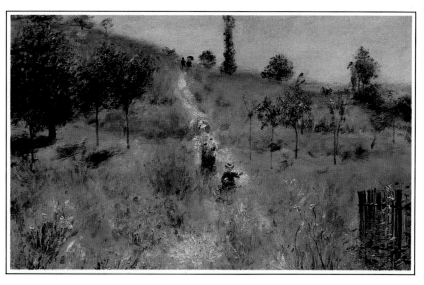

△ **Path in the Long Grass** c 1874 Pierre Auguste Renoir

Oil on canvas

DURING THE YEARS when Renoir and Monet were working together at Argenteuil, they often painted the same subjects. There are very similar pictures to this one in Monet's work. Both artists were still feeling their way in Impressionism and were at an experimental stage with many things to discover, including how to handle paint with confidence when painting out-of-doors and how to apply colour to achieve the effect of light and shade. Although landscape would never be a main interest for Renoir, he painted many places to which he felt sentimentally attached, including the countryside around Argenteuil, where this summer scene was painted.

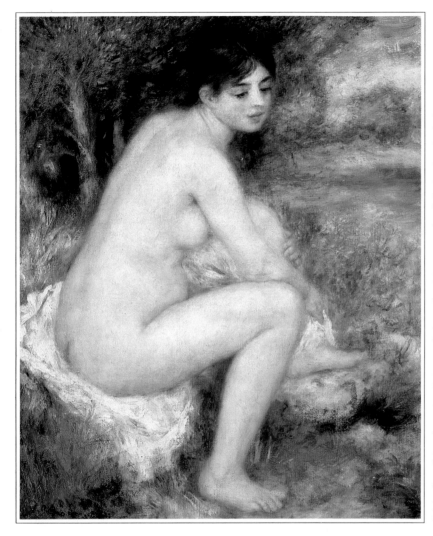

◁ **Nude in a Landscape** 1883
Pierre Auguste Renoir

Oil on canvas

'The most simple subjects are eternal . . . The nude woman, whether she emerges from the waves of the sea, or from her own bed, is Venus, or Nini; and one's imagination cannot conceive anything better.' Thus Renoir on the nude, which he painted so gloriously throughout his life. The girl in this breathtakingly beautiful painting appears to be the same dark-haired girl included by Renoir in one of his earliest great paintings on the theme of women bathing, *The Bathers* (1887), which took Renoir several years to complete. His nudes were not always painted directly from a model in the Impressionist manner, but were often the result of a long series of sketches and studies. To achieve the glowing rose and pearl effects of his subject's skin he would apply layer upon layer of fine paint. He once remarked that he made love to his models with brushstrokes.

▷ **The Cradle** 1872
Berthe Morisot (1841-95)

Oil on canvas

BERTHE MORISOT was one of
the three daughters of a
Prefect of Bourges. She and
her sister Edma (later to figure
in some of Berthe Morisot's
finest portraits) were given art
lessons by a friend of Corot, in
whose studio Morisot worked
for a time. Always a skilful
painter, Morisot found herself
early in sympathy with the
ideas of the Impressionists.
Her work was greatly admired
by Edouard Manet, whom she
met in the late 1860s and who
used her as the model for his
great painting, *The Balcony*.
It was largely Morisot's
influence that got Manet
interested in painting *en plein
air*. In turn, Manet's influence
on Morisot directed her work
towards the freely painted and
very direct style which
characterized her finest work.
This picture of a woman and
child, a recurrent theme in her
work, was included with
another eight of her paintings
in the first Impressionist
Exhibition in 1874, the year in
which she married Manet's
brother, Eugène.

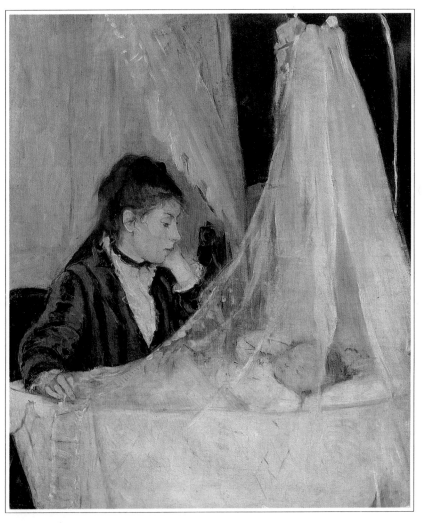

▷ **In the Garden**
Berthe Morisot

Oil on canvas

THIS SUNLIT SCENE is a little
unusual for Morisot, who
generally preferred more
domestic, indoor subjects. It is,
on the other hand, a subject
always popular with the
Impressionists as a group, for
gardens provided a vivid array
of colours and greatly varied
intensities of light, shade and
shadow with which they could
work. This painting shows
Morisot's technique at its best,
her brush moving freely over
the canvas, apparently dashing
colours on at random, but still
achieving a beautiful intensity
and variation of light.

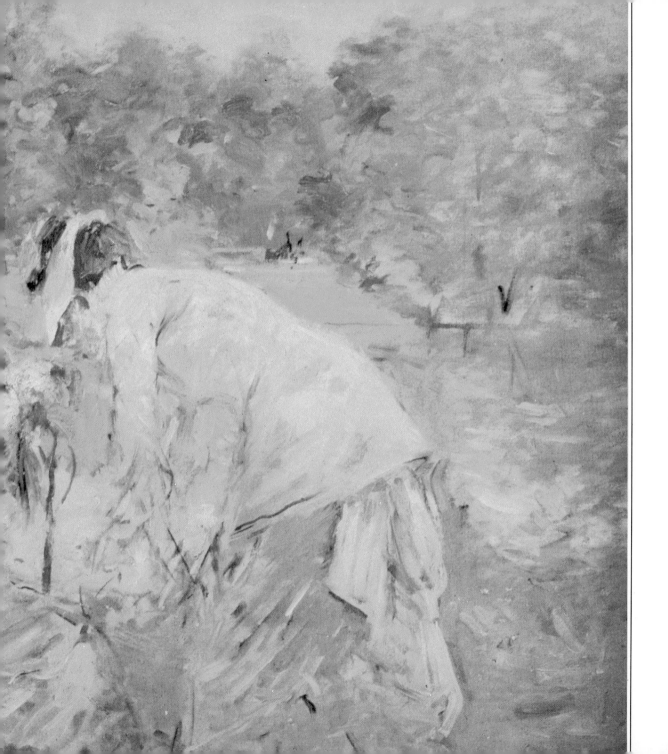

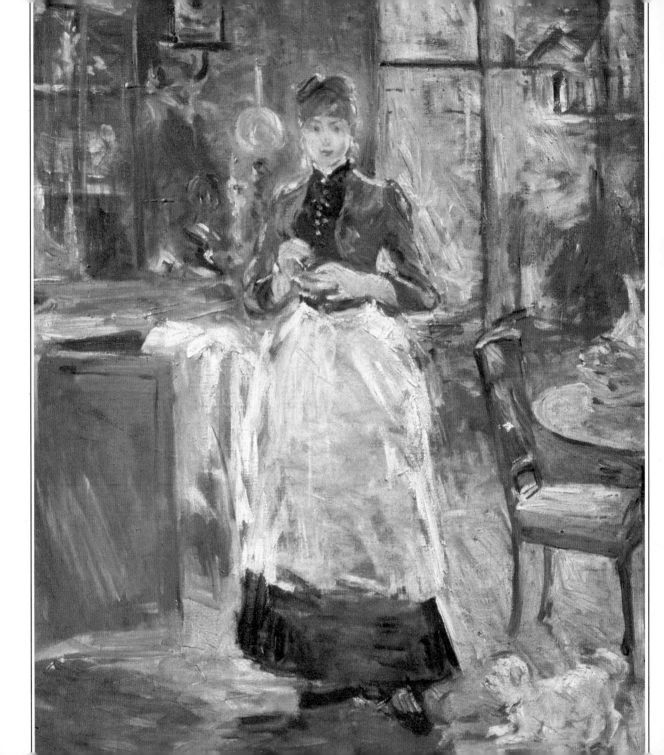

◁ **In the Dining-room** 1886
Berthe Morisot

Oil on canvas

PAINTED AT THE high point of her artistic life, Morisot's *In the Dining-room* shows her particular technique at its most effective. Unlike such Impressionist contemporaries as Monet and Sisley, Morisot has been much more dashing in the way she has built up her picture. Her colours have been put on, not in small, regular brushstrokes, but in bold, vigorous strokes in all directions. The effect is to bring light into every part of the painting. At the same time, she has managed to give the central figure of the young girl considerable charm by using a smoother style for painting her face with its cherry-red mouth and bright eyes. The painting was one of 14 she showed at the last Impressionist Exhibition of 1886, which she was largely responsible for organizing.

Réunion de Famille 1867
Frédéric Bazille (1841-70)

Oil on canvas

▷ *Overleaf, see pages 54-55*

BAZILLE WAS ONE of the founder members of the group of artists who came to be called Impressionists. The quality of his early work has caused many people to think that his death in action during the Franco-Prussian War robbed the group of potentially its finest painter. His *Family Reunion,* painted partly in the open air, reveals his rare talent, comparing favourably with Monet's *Women in the Garden.* The setting for the painting is the terrace of Bazille's family home at Montpellier, where his father was a wealthy wine merchant, and the people are members of his family. Unlike some of his fellow artists, Bazille had the means to develop his artistic career in financial comfort and his large studio, which was the subject of one of his best-known paintings, was a haven for his friends, several of whom he had met while studying at Gleyre's studio.

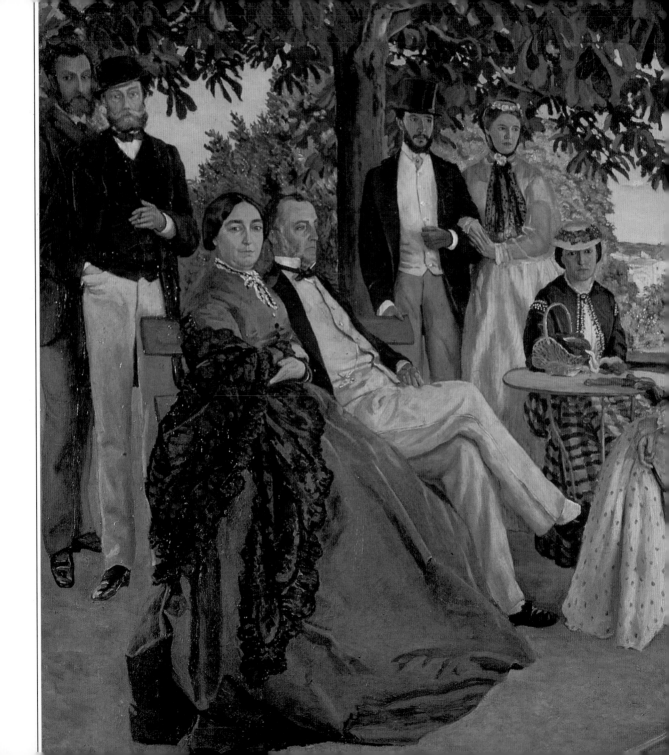

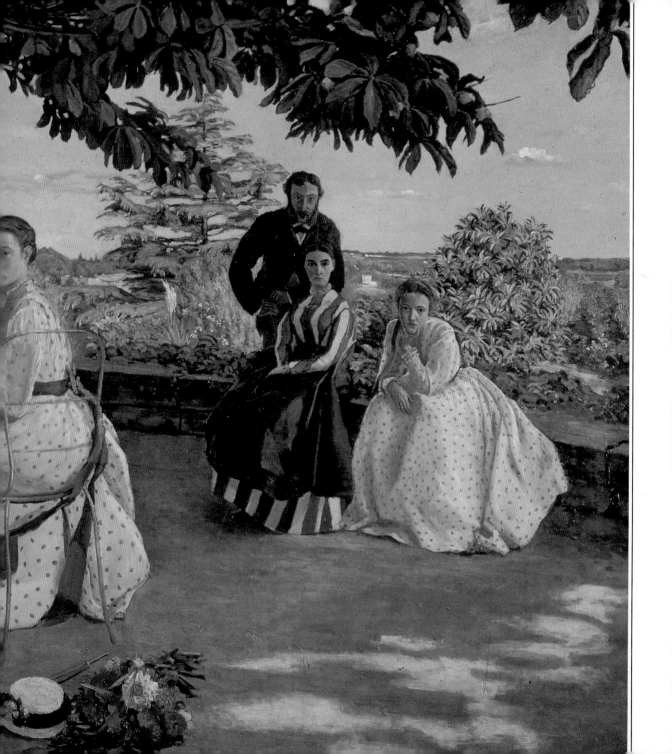

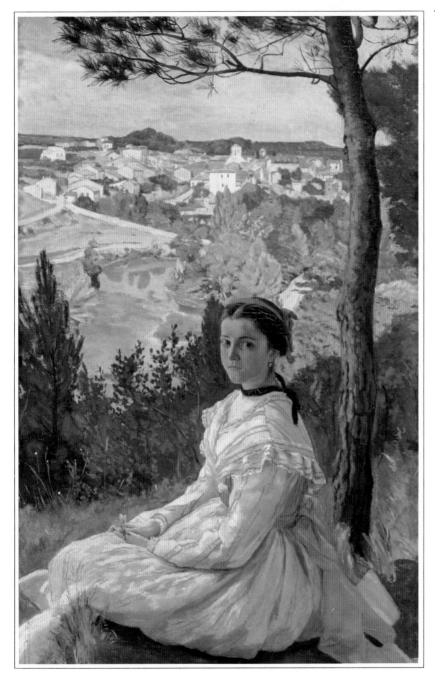

◁ **View of the Village of Castelnau** 1868
Frédéric Bazille

Oil on canvas

BERTHE MORISOT was very impressed by this painting when she saw it exhibited at the 1869 Salon. 'The tall Bazille has painted something that is very good,' she wrote. 'It is a little girl in a light dress seated in the shade of a tree, with a glimpse of a village in the background. There is much light and sun in it. He has tried to do what we have so often attempted – a figure in the outdoor light – and he seems to have been successful.' The challenging combination of sun and shadow here might well have been painted by an artist of an earlier generation in a chiaroscuro style, with the shadows given a deep brown colour. Bazille, fully in sympathy with Impressionist aims, has instead given colour to the shade.

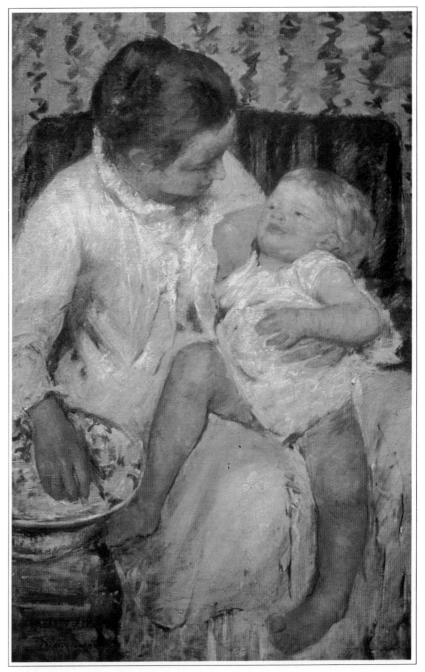

▷ **Mother Bathing Her Child** 1880
Mary Cassatt (1844-1926)

Oil on canvas

AMERICAN-BORN Mary Cassatt was the daughter of a well-off Pittsburgh businessman. She had her first painting accepted for the Paris Salon in 1874, the year she arrived in Paris, and she also exhibited works in most of the eight Impressionist exhibitions. Like Berthe Morisot, she tended to concentrate on domestic subjects, depicting themes of everyday life with a wonderful sensitivity. From the late 1870s the 'mother and child' theme was prominent in her work, though, as the art critic and novelist Joris-Karl Huysmans noted, there was none of the sentimentality, which so often affected English painters, in her work. Seeing her work in the 1881 Impressionist exhibition, Huysmans noted, 'For the first time in my life, thanks to Mlle Cassatt, I have seen images of ravishing children, tranquil scenes of bourgeois life, painted with a kind of delicate tenderness which is completely charming.'

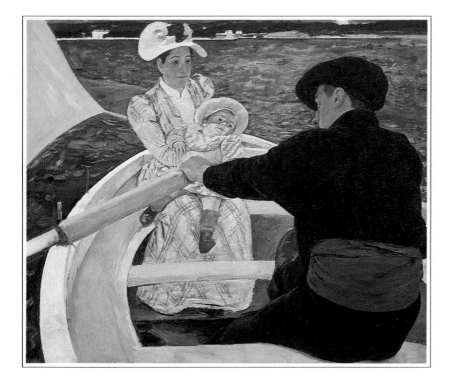

△ **A Ride in a Rowing Boat** 1894 Mary Cassatt

Oil on canvas

THIS TECHNICALLY very interesting painting was the centrepiece of Cassatt's first solo exhibition in New York, at Durand-Ruel's Gallery in 1895. It was painted at Antibes, in the south of France, where Cassatt had been spending long periods for several years. Painted *en plein air,* the picture shows the influence of Japanese painting on Cassatt's art, particularly in her abstract treatment of the sail and the foreshortening of the boat, and her inclusion of large flat planes of very dark colour; there is much more black in this painting than was generally acceptable to the Impressionists.

▷ **Allée des Alyscamps,
Arles** 1888 Paul Gauguin
(1848-1903)

Oil on canvas

PAUL GAUGUIN was a young
stockbroker in Paris when he
visited the first Impressionist
Exhibition in 1874. He was so
overwhelmed by what he saw
that he decided that he, too,
must become an artist. It was
Pissarro who took the young
man under his wing, giving
him much useful advice. Later,
however, Impressionist
influence on Gauguin
diminished in the face of new
ideas he encountered on
meeting van Gogh, Seurat and
Signac. Gauguin spent a
traumatic few weeks with van
Gogh in Arles in 1888, during
which the two artists often
went on painting expeditions
together. The Allée des
Alyscamps, a promenade
bordered by trees and Roman
sarcophagi, featured in
paintings by both artists.
Gauguin's painting shows him
experimenting with the bold
colour techniques of the
Impressionists, though there is
a hint, too, of the exotic colour
combination he was to adopt
in his South Sea Islands
paintings of the 1890s.

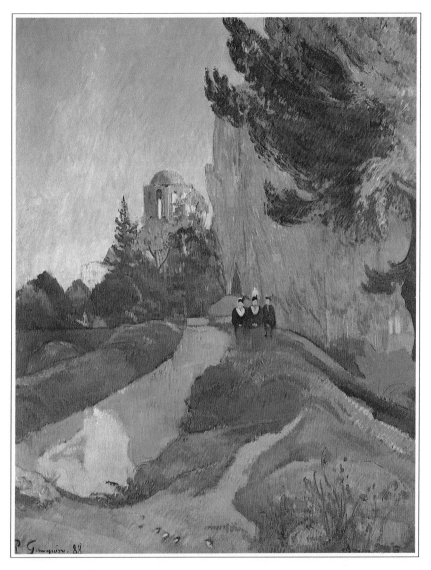

▷ **The Vision after the Sermon** 1888 Paul Gauguin

Oil on canvas

AN ALTERNATIVE TITLE for this painting is *Jacob Wrestling with the Angel*. Painted while Gauguin was staying in Brittany, it marks the beginning of his divergence from the influences of Impressionism. Not only is the painting telling a story, in a flat, simplified style which owes much to the influence of Japanese painting, but Gauguin has chosen to use his vivid red in a symbolic way, denoting conflict. Gauguin's stay in Brittany began his move away from the rational good sense of the Impressionists towards a sort of romantic mysticism which Pissarro, for one, found deplorable. 'Our philosophy of today . . . is an out-and-out social philosophy and an anti-authoritarian and anti-mystical philosophy', he declared, adding that Gauguin was in error in moving away from it.

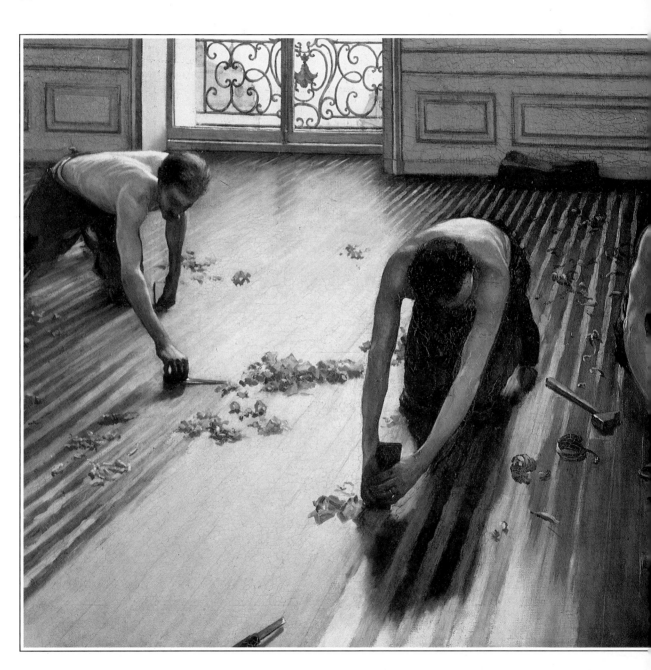

◁ **Planing Parquet** 1875 Gustave Caillebotte (1848-94)

Oil on canvas

A WEALTHY LAW STUDENT and naval designer, Gustave Caillebotte developed into a painter of great originality, concentrating on pictures of urban life. This painting of men stripping a wood floor shows his technique at its best. There is a fine observation of the fall of light and shade on the scene, which is painted from an unusual viewpoint and emphasises the unposed gestures of the men. This painting was the only work by himself included in the magnificent Caillebotte Gift which he left to the French nation in his will. His collection, built up during a lifetime of support for the cause of Impressionism, included 16 paintings by Monet, 13 by Pissarro, 8 each by Renoir and Sisley, 7 by Degas, 5 by Cézanne and 3 Manets. For many years, this magnificent gift formed the basis of the Jeu de Paume collection in Paris, but it was moved to the Musée d'Orsay when that superb museum and gallery opened in Paris in 1986.

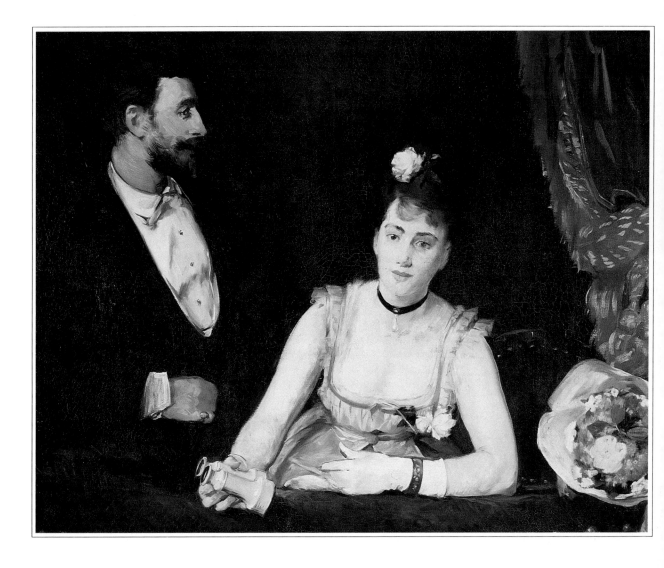

◁ **A Box at the Italians' Theatre** 1874 Eva Gonzalès (1849-83)

Oil on canvas

EVA GONZALES began her art studies with the academician Chaplin, but became Manet's only pupil shortly after she met him in 1867. Although it was inevitable that her painting should have been influenced by him early in his tutelage, she had a strong enough character quickly to develop a style of her own. In 1870, the year in which Manet painted the portrait of her reproduced on page 20, Gonzalès had a picture of a boy soldier accepted for hanging at the Salon. Much of her later painting showed a taste for social realism. Her painting of a couple at the theatre, its dark tones owing more to academic style than to Impressionism, was painted in the same year as Renoir's *La Loge*.

△ **The Donkey Ride** c 1880 Eva Gonzalès

Oil on canvas

PAINTED TOWARDS the end of her life, this painting shows Gonzalès as an artist remaining true to her belief in Manet's style while also embracing the tenets of Impressionism. It is a pleasant, everyday event being depicted here, but the beautifully lit face of the woman on the donkey has nothing to do with academic, studio lighting. This is painting *en plein air* of a high order. Eva Gonzalès, who had married the engraver, Henri Guérard in 1878, died in childbirth in 1883, shortly after the death of Manet. Their deaths were a double loss to 19th-century art.

▷ **Green Wheatfield with Cypress** 1889 Vincent van Gogh
(1853-90)

Oil on canvas

THE SON OF A DUTCH
Protestant minister, Vincent
van Gogh was a follower of
Impressionism, particularly in
his early years, rather than an
Impressionist painter. The
Impressionists' attitude to
colour had a great effect on
the young van Gogh's work
when he discovered them in
Paris, freeing his style from the
constrictions of the heavy,
monochromatic palette he had
hitherto used. Towards the
end of his life, working
frantically between bouts of
madness for which he himself
could see no cure, he devised a
technique which allowed him
to produce paintings very

quickly, in a style uniquely his.
This splendid painting of a
wheatfield near Saint-Rémy-
en-Provence, was done while
van Gogh was a voluntary
patient at a mental asylum in
the town. While there, he
suffered several bouts of
madness lasting weeks at a
time. When he could paint,
his work swung between
cheerful studies such as this
and rather morbid pictures of
tormented skies and cypress
trees blown in high winds.
Always a religious man, he saw
Nature as the handiwork of
God, in whom his trust did not
falter, despite his own terrible
misfortunes.

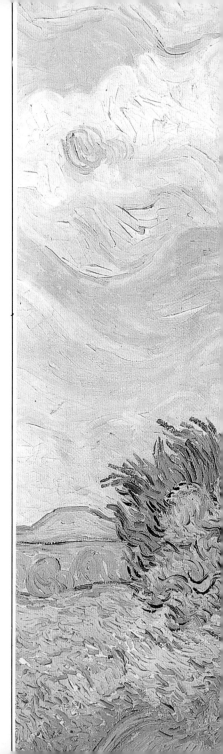

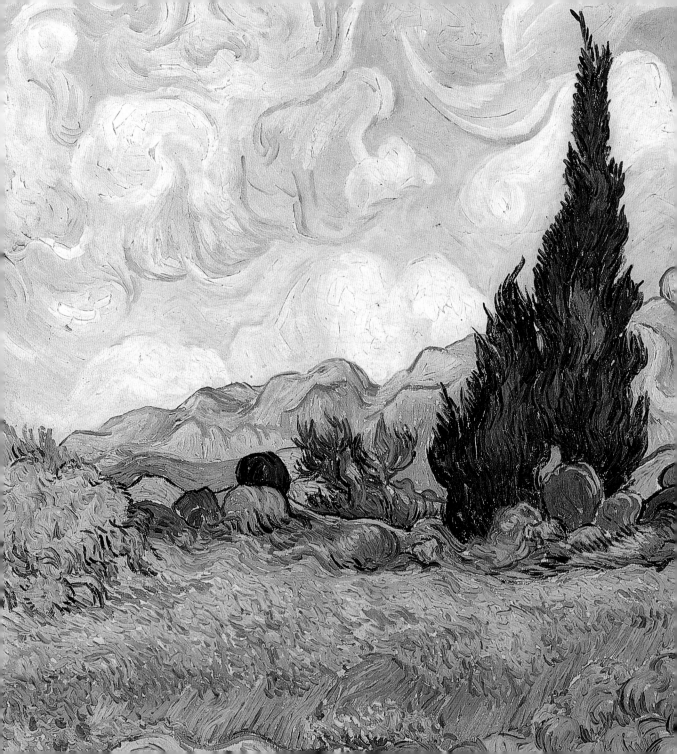

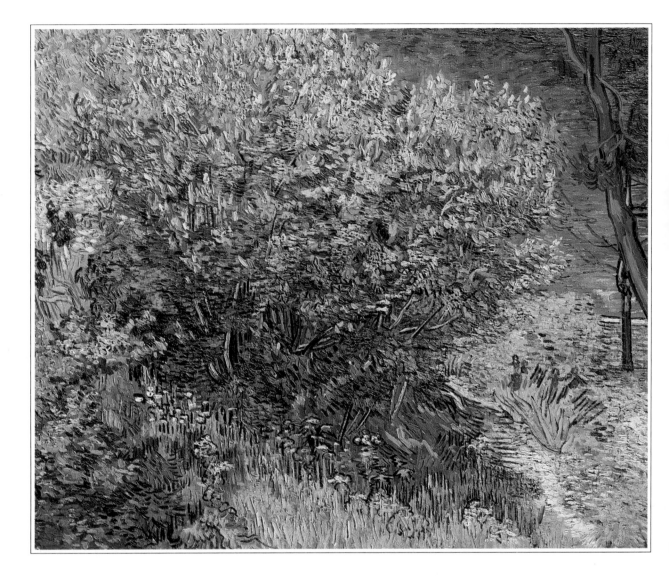

◁ **The Lilac Bush** 1889
Vincent van Gogh

Oil on canvas

THIS EXUBERANT PAINTING, done while van Gogh was in the asylum in Saint-Rémy-en-Provence, reveals a great deal about his technique and his dynamic methods. The Impressionist use of colour and the Impressionists' interest in the Japanese style of composition are both evident here, though so, too, is his personal way of working. He had developed a technique, suited to very quick working, whereby he washed in indications of colour in large areas and covered them with firm brushstrokes, the direction of which gave a sense of the form of the subject he was painting and also helped create a rhythm for the composition as a whole. Using this technique, he was able to paint hundreds of works in the two and a half years between his reaching maturity as a painter and his death.

△ **Street in Auvers** 1890 Vincent van Gogh

Oil on canvas

IN 1890 van Gogh moved from Saint-Rémy to the quiet town of Auvers-sur-Oise, in the north of France, at the suggestion of Pissarro, who knew of a doctor in the town who might be able to help him. Van Gogh put himself into the care of Dr Paul-Ferdinand Gachet, a homeopathic doctor and art collector. The two men became friends and van Gogh was soon hard at work, painting numerous portraits (which he considered the highest art form), including two of Dr Gachet, as well as landscapes and views of corners of the picturesque village. This group of buildings was painted by van Gogh in May 1890, just two months before he shot himself in a field where he had been painting. He died two days later.

▷ **Sunday Afternoon on the Island of La Grande Jatte** 1884-6
Georges Seurat (1859-91)

Oil on canvas

THIS PAINTING created a considerable stir when it was shown at the last Impressionist Exhibition in Paris in 1886, for it seemed to contribute something new to Impressionism, carrying its exponents use of colour into uncharted territory. Georges Seurat had been greatly influenced by several published works analysing various scientific theories of colour. A result of his studies was the invention of Divisionism (or Pointillism), which was based on Optical Mixtures – the idea that colour was more potent when two primary colours were placed side by side as dots, so that the mixing of the colour would take place in the viewer's eye. To paint this great work, Seurat made hundreds of studies, gradually assembling them into an intellectual composition based on the theory of the Golden Section. The result, to our eyes, is an impeccable painting with much intellectual force, though perhaps lacking in that *élan-vital,* so important to Delacroix, the painter Seurat admired before all others.

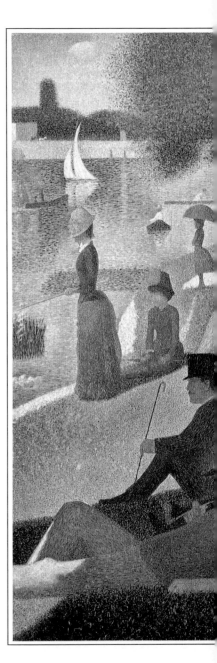

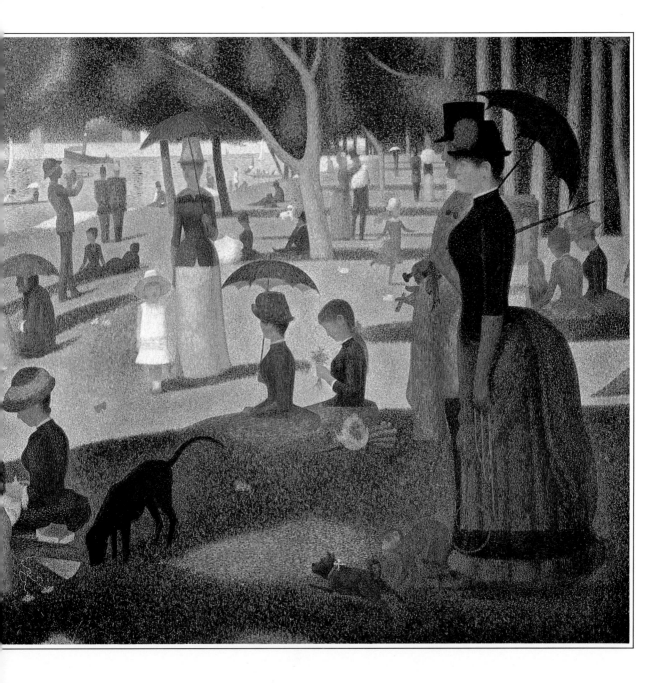

▷ **Girls Running,
Walberswick Pier** 1894
Philip Wilson Steer
(1869-1942)

Oil on canvas

PHILIP WILSON STEER was the
first British painter to work in
a fully-fledged Impressionist
manner, producing many
pictures of open-air scenes
flooded with a sparkling light
and painted in vibrant colours.
He probably first encountered
the Impressionists' work at
an exhibition in London in
1883, he further deepened
his appreciation and
understanding of their aims
and techniques during a
period of study in Paris later
in the 1880s. Back in England,
he concentrated on painting
highly-coloured seaside and
maritime scenes, most of them
done either on the Suffolk
coast at Walberswick or in
France around Boulogne.
This lively painting of girls
on the pier at Walberswick,
while it brilliantly conveys
the deepening light and
lengthening shadows of the
end of the day, also shows a
strongly divisionist influence
in the placing of the dots of
colour.

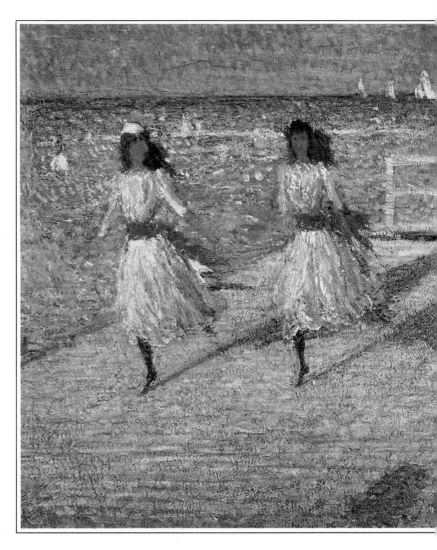

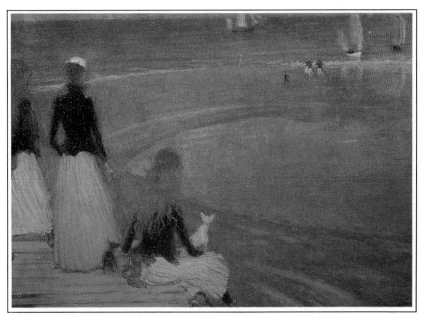

△ **The Beach at Walberswick** c 1890 Philip Wilson Steer

Oil on canvas

SOMETHING of a transitional painting, this beach scene shows Philip Wilson Steer moving towards the more subdued style and palette which characterized his paintings from the mid-1890s. Wonderfully vibrant colours, especially reds and blues, are still being used to great effect, but the whole scene is quieter, less zestful than *Girls Running, Walberswick Pier*. Like many artists working in the Impressionist style, Wilson Steer became unhappy with the diffuse colour of Impressionist theory, and began looking for more formal elements to give his paintings structure, in the more English tradition of Turner and Constable.

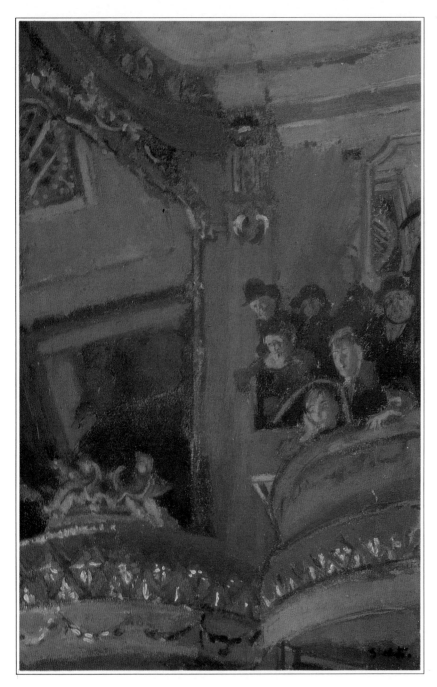

◁ **The Old Bedford Music Hall** 1894-5
Walter Sickert (1860-1942)

Oil on canvas

THOUGH CONSIDERED to be, in his early years, an 'English Impressionist', Sickert used many of the traditional techniques of the Old Masters in his work, though he also tended to choose to paint the sort of everyday scenes depicted by his friend Degas, whom he met in Paris in the 1880s and who had considerable influence on Sickert's work. Like Degas, Sickert painted theatre scenes many times, probably influenced by his early training as an actor. Sickert's theatre was a much more down-to-earth, even bawdy, place than Degas's, his liking for low life making him more akin to Toulouse-Lautrec. He once remarked that 'taste is the death of a painter', believing that painting was a 'gross art', more at home in the kitchen than the drawing-room.

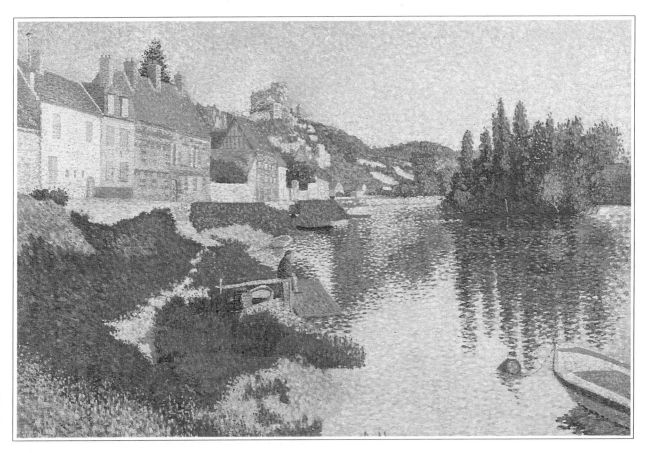

△ **River Bank at Petit-Andely** 1886 Paul Signac (1863-1935)

Oil on canvas

PAUL SIGNAC was a keen disciple of Seurat and, like Seurat, given to the enthusiastic promotion of aesthetic theories of art. His book, *De Delacroix à Neo-Impressionisme,* which set out to promote the ideas of Divisionism (or Pointillism, as it was more popularly called), became the text-book of Seurat's theories. Signac was remarkably loyal to the Divisionist idea, as can be seen in this painting of a small village on the Seine. He has broken up the colour in small brushstrokes and spread the colours of the light into the dark areas of the picture to give them more life. As this painting also hints at, the effect of all these small points of colour was to make a painting look mechanical and repetitive, which is why painters later in the century broke away from the whole idea of broken colour and launched themselves into Fauvism.

▷ **Jeanne Avril Dancing** 1892
Henri de Toulouse-Lautrec
(1864-1901)

Gouache on paper

THE SON OF AN ANCIENT,
aristocratic family of southern
France, Henri de Toulouse-
Lautrec turned to painting as
compensation for his inability
to pursue country sports when
bone disease caused both his
legs to break and his growth to
be stunted in his teens. He
enrolled in the studio of the
artist Cormon in Paris, where
a fellow-student was Vincent
van Gogh. By 1884 he had his
own studio in Paris and was
beginning to paint the night-
life of the city, including its
dance-halls and brothels.
While Impressionism was an
influence on Toulouse-
Lautrec, especially in his use of
colour, Degas's work as an
interpreter of Parisian life was
a greater inspiration, as were
the methods of Japanese print
artists. All three strands of
influence can be seen in this
famous study of Jeanne Avril
dancing at the Moulin Rouge
in Montmartre.

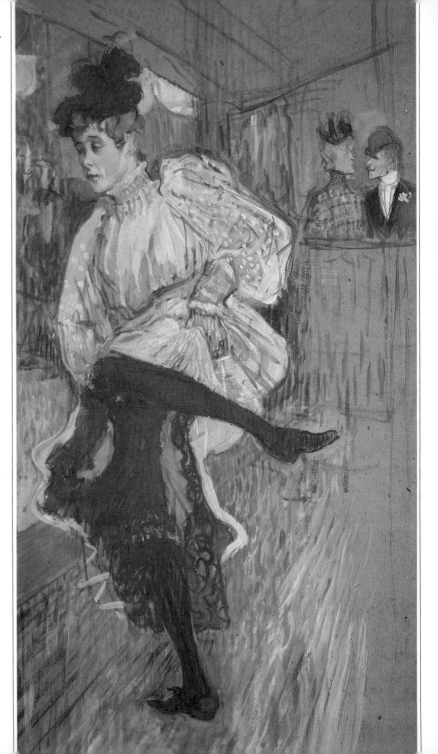

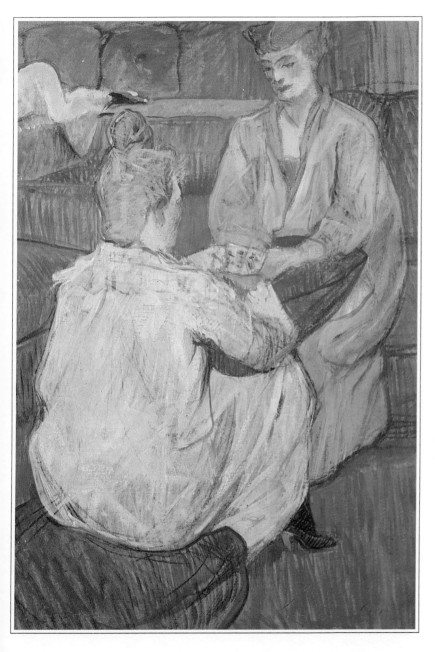

◁ **The Card Players** c 1893
Henri de Toulouse-Lautrec

Mixed media

HENRI DE TOULOUSE-LAUTREC
was a brilliant draughtsman,
using his skills to depict a
world, half brilliant, half
sordid, that was quite
unknown to most of the
bourgeoisie of his time. Here
he shows two prostitutes
whiling away the time in their
brothel with a pack of cards.
Although this is obviously a
quickly completed drawing,
little more than a sketch, the
artist has cleverly
individualized the two women,
giving them characters of their
own. He has thus introduced
ideas of narrative and
psychology into his picture in
a way totally at variance with
the Impressionists' insistence
on objectively studying colour
and light.

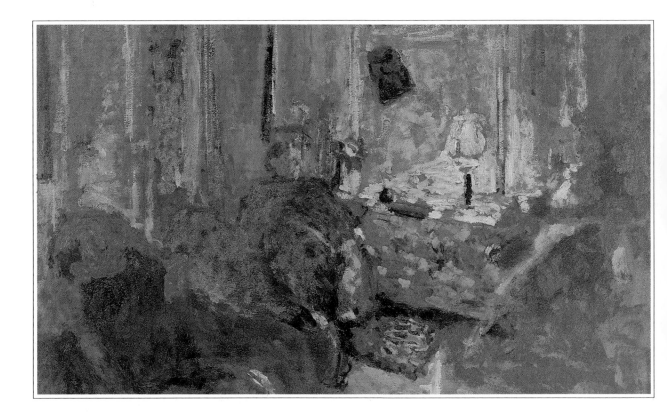

△ **Interior with Mme Vuillard** c 1910 Edouard Vuillard (1868-1940)

Oil on canvas

VUILLARD, like his friend Pierre Bonnard, was a quiet, unassuming and un-bohemian character who liked nothing better than to set up his easel in the peace of his own home. He and Bonnard were both in a small group of French painters known as *les Nabis*, from a Hebrew word meaning 'prophet'. Attracted by Gauguin's practice of painting in flat, pure colours, they had chosen the title to signify the fact that they were painters of the future, especially in the way they used colour. Initially reacting strongly against the Impressionists' implicit naturalism, both Vuillard and Bonnard returned to a sort of modified Impressionism, known as 'Intimisme', of which this study of a quiet evening in Vuillard's sitting-room in a pleasant example.

ACKNOWLEDGEMENTS

The Publisher would like to thank the following for their kind permission to reproduce the paintings in this book:

Bridgeman Art Library, London/Art Institute of Chicago, USA70-71; /**Carnegie Institute, Pittsburgh, Pennsylvania**14-15; /**Christie's, London** 10-11, 12-13, 31, 33, 46-47, 78; /**City of Bristol Museum and Art Gallery** 65; /**Fitzwilliam Museum, University of Cambridge** 74; /**Giraudon/Musée d'Orsay**8-9, 26-27, 36-37, 48, 49, 59, 62-63, 76; /**Giraudon/Musée Fabre, Montpellier** 56; /**Giraudon/Louvre, Paris** 47; /**Hermitage, St Petersburg** 44, 68; /**Index/National Gallery of Art, Washington D.C.** 58; /**Kunstanyn Museum, Helsinki** 69; /**Lauros-Giraudon/Musée de l'Orangerie** 45; /**Louvre, Paris**29, 54-55; /**Metropolitan Museum of Art, New York** 22-23; /**Minneapolis Society of Fine Arts, Minnesota** 30; /**Musée des Beaux-Arts, Tournai** 21; /**Musée d'Orsay, Paris** 64; /**National Gallery, London** 66; /**National Gallery of Art, Washington DC** 52; /**National Gallery of Scotland, Edinburgh** 60-61; /**National Museum, Stockholm** 50-51; /**Neue Pinakothek, Munich** 24; /**Private Collection** 20, 32, 34-35, 38-39, 57, 75, 77; /**Pushkin Museum, Moscow** 16-17, 25, 42-43; /**Tate Gallery, London** 18-19, 72-73, 73.